You Can Draw

Rockets

SALARIYA

Published in Great Britain in MMXII by
Book House, an imprint of
The Salariya Book Company Ltd
25 Marlborough Place, Brighton BN1 1UB

1 3 5 7 9 8 6 4 2

Please visit our websites at **www.salariya.com** or
www.book-house.co.uk for **free** electronic versions of:
You Wouldn't Want to Be an Egyptian Mummy!
You Wouldn't Want to Be a Roman Gladiator!
You Wouldn't Want to be a Polar Explorer!
**You Wouldn't Want to Sail on a 19th-Century
Whaling Ship!**

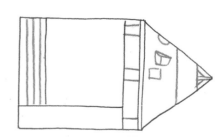

Author: Mark Bergin was born in Hastings in 1961. He
studied at Eastbourne College of Art and has specialised
in historical reconstructions as well as aviation and
maritime subjects since 1983. He lives in Bexhill-on-
Sea with his wife and three children.

Editor: Rob Walker

PB ISBN: 978-1-908759-56-6

A CIP catalogue record for this book is available from
the British Library.

Printed and bound in China.
Printed on paper from sustainable sources.

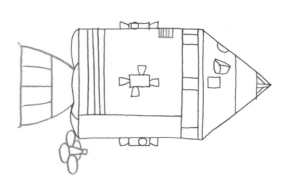

Visit our **new** online shop at

shop.salariya.com

for great offers, gift ideas, all our new releases

and free postage and packaging.

PAPER FROM
SUSTAINABLE
FORESTS

You Can Draw

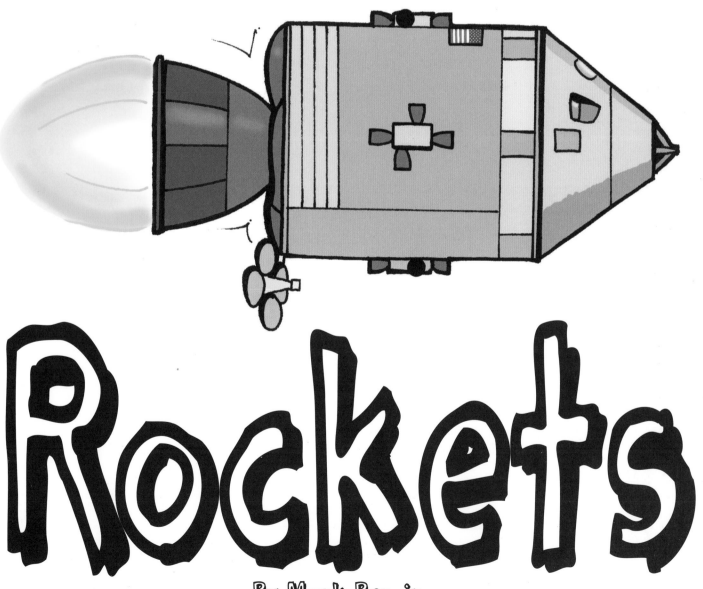

Rockets

By Mark Bergin

Contents

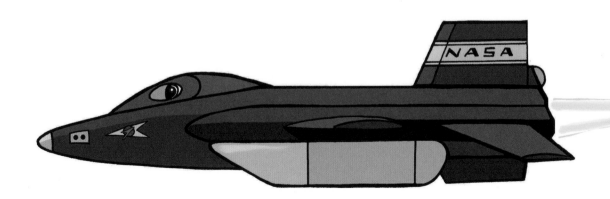

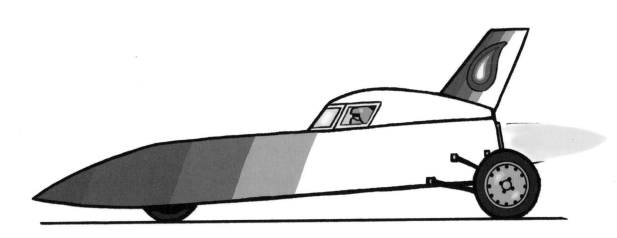

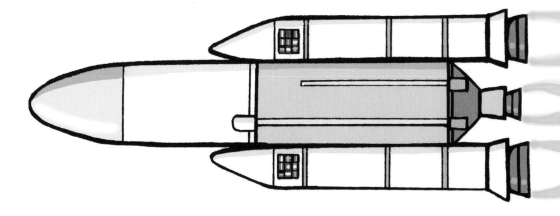

Introduction

Learning to draw is fun. In this book a finished drawing will be broken up into stages as a guide to completing your own drawing. However, this is only the beginning. The more you practise, the better you will get. Have fun coming up with cool designs, adding more incredible details and using new materials to achieve different effects!

This is an example showing how each drawing will be built up in easy stages. New sections of the drawing will be shown in colour to make each additional step clear.

1

2

3

4

5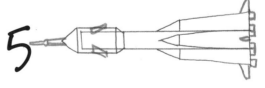

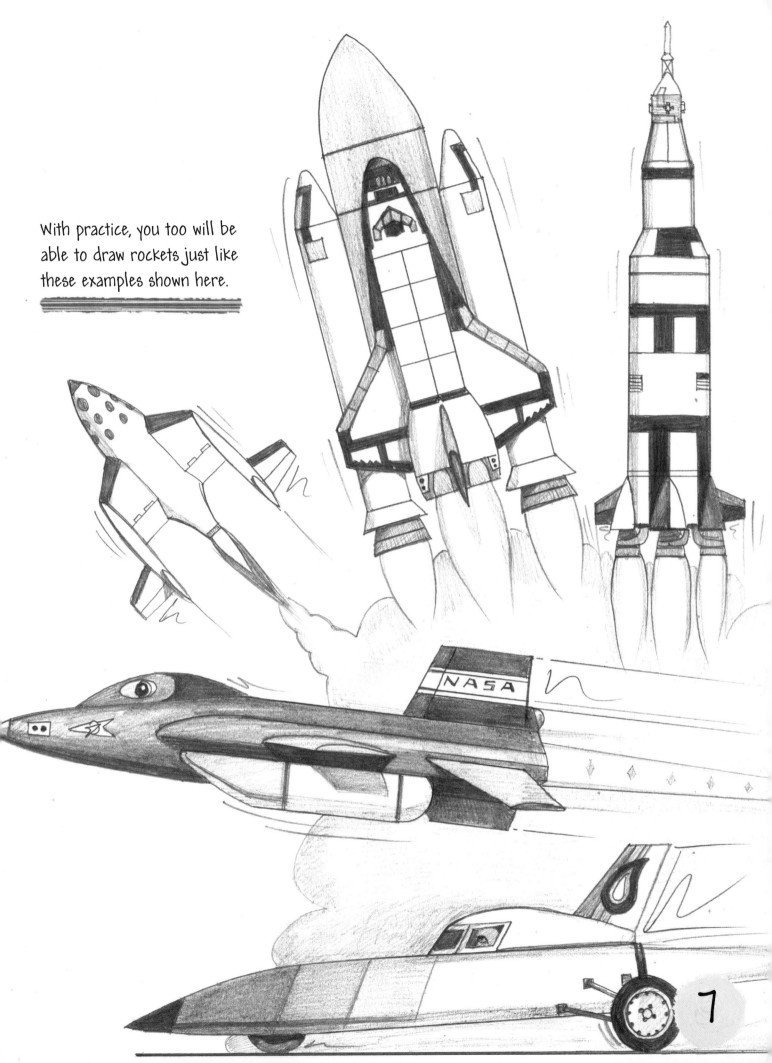

With practice, you too will be able to draw rockets just like these examples shown here.

Materials

There are many different art materials available which you can use to draw and colour in your vehicles. Try out each one for new and exciting results. The more you practise with them, the better your drawing skills will get!

Use a pencil to draw the shape of your rocket. Any mistakes you make can easily be erased, as can any construction lines that are left over at the end of your drawing.

An eraser can be used to rub out any pencil mistakes. It can also be used to create highlights on pencil drawings.

You can go over your finished pencil lines with pen to make the lines bolder. But remember, a pen line is permanent so you can't erase any mistakes!

Coloured pencils come in a huge range of colours and can be layered over each other for new and exciting effects.

Pastels can be smudged and blended together to give you all sorts of different colours.

Felt tip pens can add vibrant colour to your drawing. But remember that they are hard to layer and the colour is permanent so you can't erase any mistakes!

Inspiration

Many types of rockets are made throughout the world. You can choose any of them as the inspiration for your cartoon-style drawing. Looking at photos, magazines or books can give you new ideas and new designs to try.

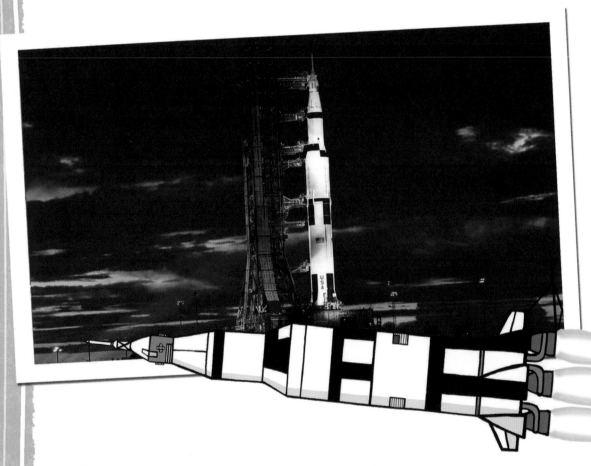

When turning your rocket into a cartoon-style, two-dimensional drawing, concentrate on the key elements you want to include and the overall shape of the rocket.

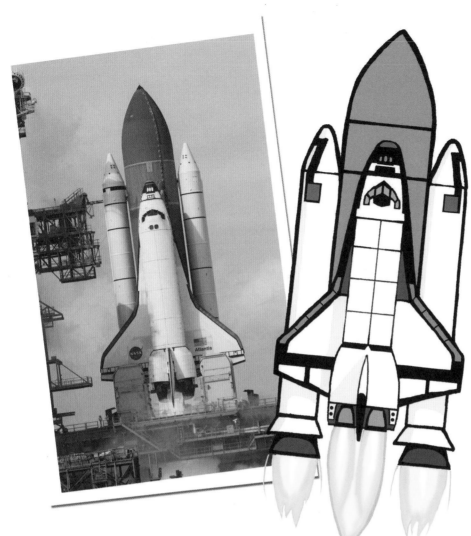

One way to make your rocket look cool is to exaggerate its key features and perhaps add new ones!

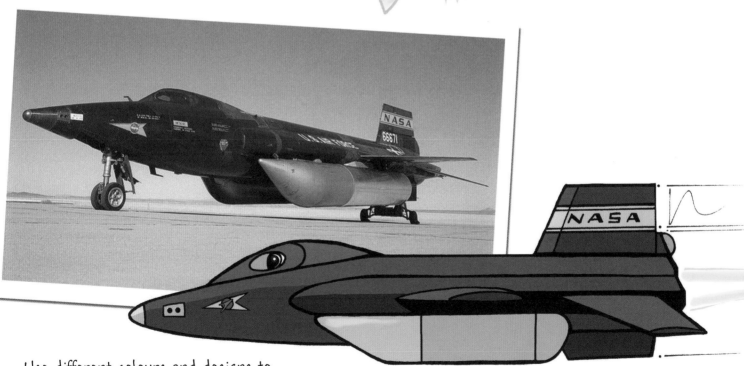

Use different colours and designs to make your rocket look the way you want it to. It's your creation after all.

Mercury-Redstone

The Mercury-Redstone was a rocket in NASA's Mercury programme. It achieved sub-orbital flight in the 1960s.

Draw a tall rectangle for the main body of the Redstone rocket and divide it into three sections (as shown).

Add more dividing lines and draw in a rectangle overlapping the base.

Draw in lines to connect the rectangle to the main body. Add fins.

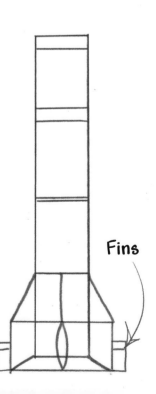

Fins

Mercury spacecraft

Draw in the Mercury spacecraft on top of the Redstone rocket. Add the rocket nozzles to the base of the rocket.

Nozzles

Escape tower

Add more detail to the Mercury spacecraft and draw in the escape tower. Add lines to the top section of the rocket.

Colour in your Mercury-Redstone rocket. This launch had a red escape tower and black and white markings.

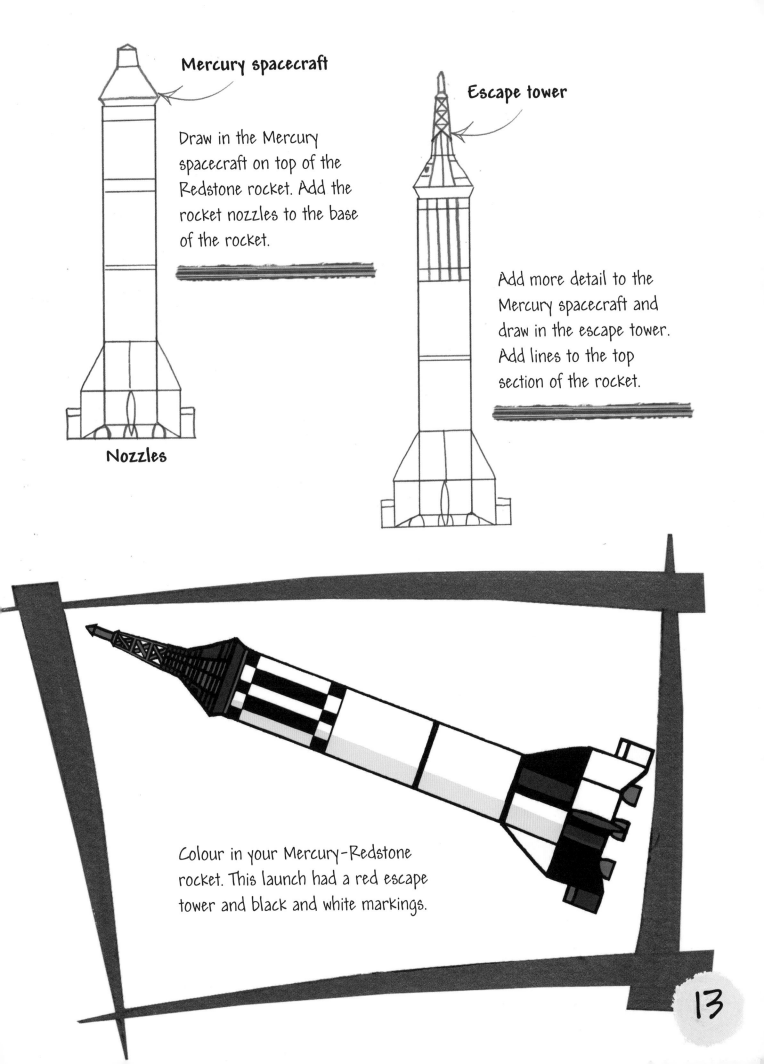

Saturn V

Saturn V is the largest rocket ever operated and was used by NASA for manned spaceflights.

Draw a tall rectangle for the main body of the rocket. Divide it into four sections.

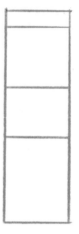

Add detail to each of the main rocket sections.

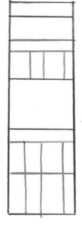

Draw in the top section of the rocket.

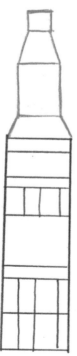

Draw the nose of the rocket's command module. Add fairings and fins to the base of the main rocket section.

Fin

Fairings

Draw in the escape tower and add detail to the command module. Add the rocket nozzles and large jets of flame coming out of them.

Complete your drawing by finishing off all the remaining details, then add colour.

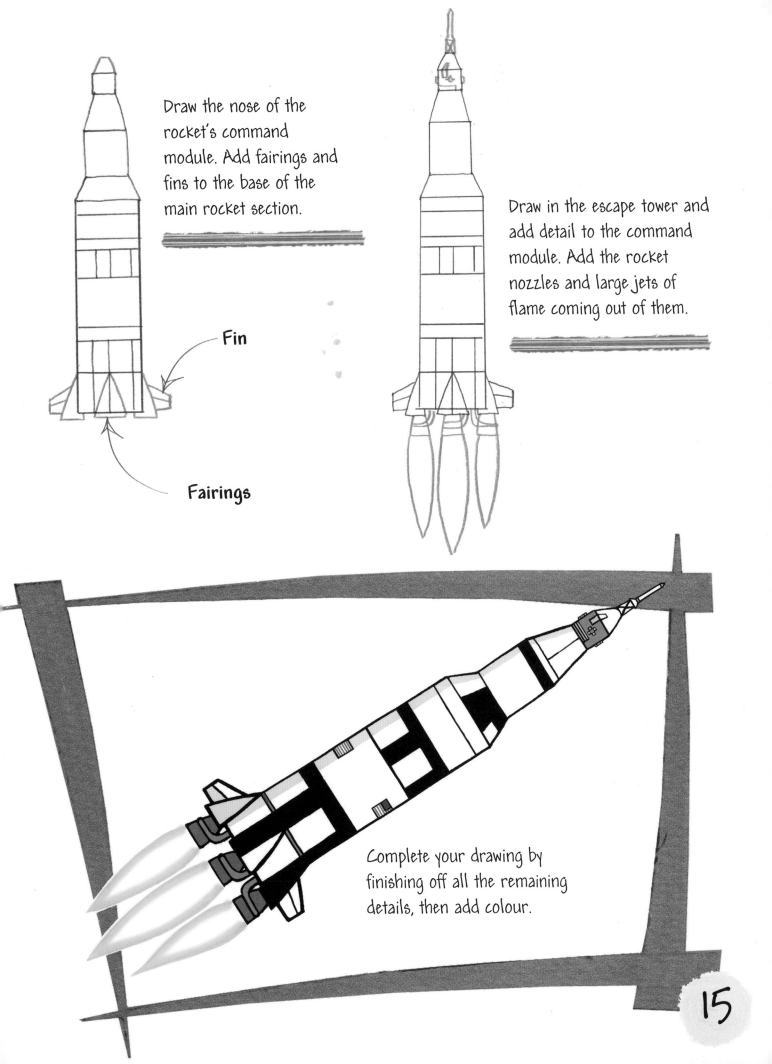

15

Apollo CSM

The Apollo CSM (command/service module) could carry three crew members. It was used to reach the Moon.

Draw a large box shape for the main body of the CSM and add a pointed nose section.

Divide the main body into sections as shown.

Add more details to the nose section and to the main body.

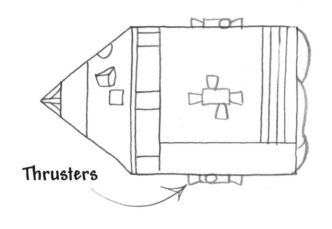

Thrusters

Draw in small sets of thrusters on the body and add the bottom of the CSM.

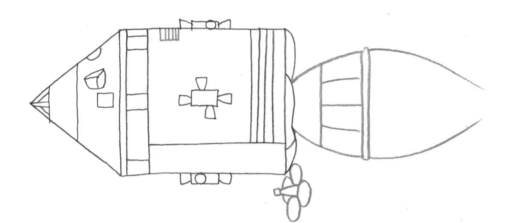

Draw in the rocket nozzle with a large flame coming out of it. Add an antenna and any remaining details.

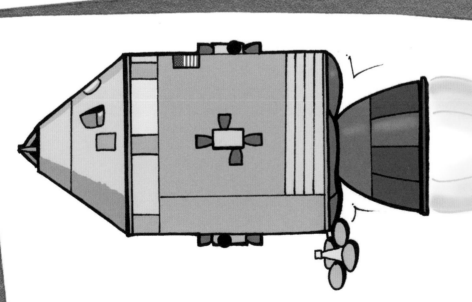

To complete your drawing add colour to each section.

X-2

The Bell X-2 was an experimental aircraft which flew at supersonic speeds using a special rocket engine.

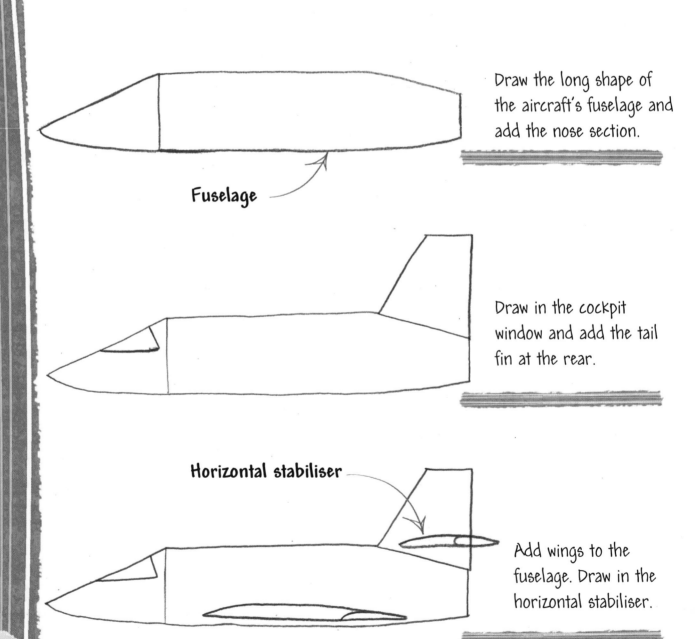

Fuselage

Draw the long shape of the aircraft's fuselage and add the nose section.

Draw in the cockpit window and add the tail fin at the rear.

Horizontal stabiliser

Add wings to the fuselage. Draw in the horizontal stabiliser.

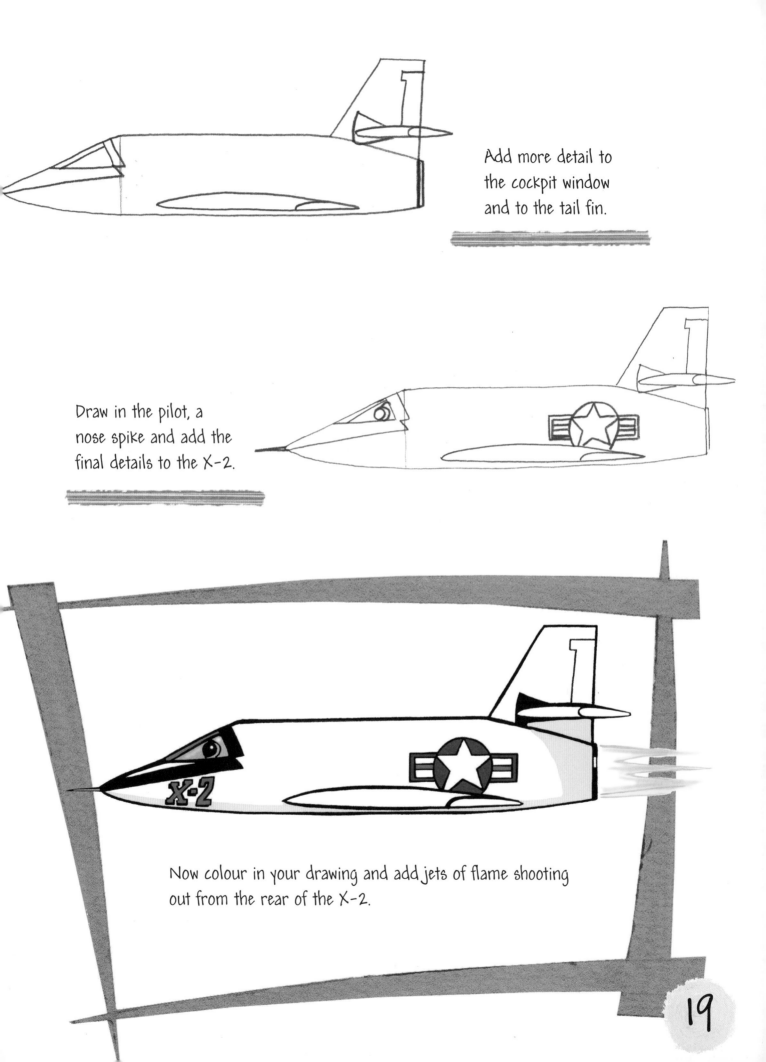

Add more detail to the cockpit window and to the tail fin.

Draw in the pilot, a nose spike and add the final details to the X-2.

Now colour in your drawing and add jets of flame shooting out from the rear of the X-2.

Blue Flame

The Blue Flame was a rocket-powered vehicle that held the land speed record for 13 years. It reached 1,014.513 kph (630.388mph) in 1970.

Start by drawing in the long bullet-shaped body (keep the rear end slightly raised). Add a line for the ground.

Draw in the wheels. The front wheel is partially hidden.

Stabilisers

Draw in the rear wheel stabilisers and add detail to each wheel.

Draw in the cockpit shape and add a window and the driver's head.

Cockpit

Draw in the paintwork design and add a fin and a jet of flame at the rear.

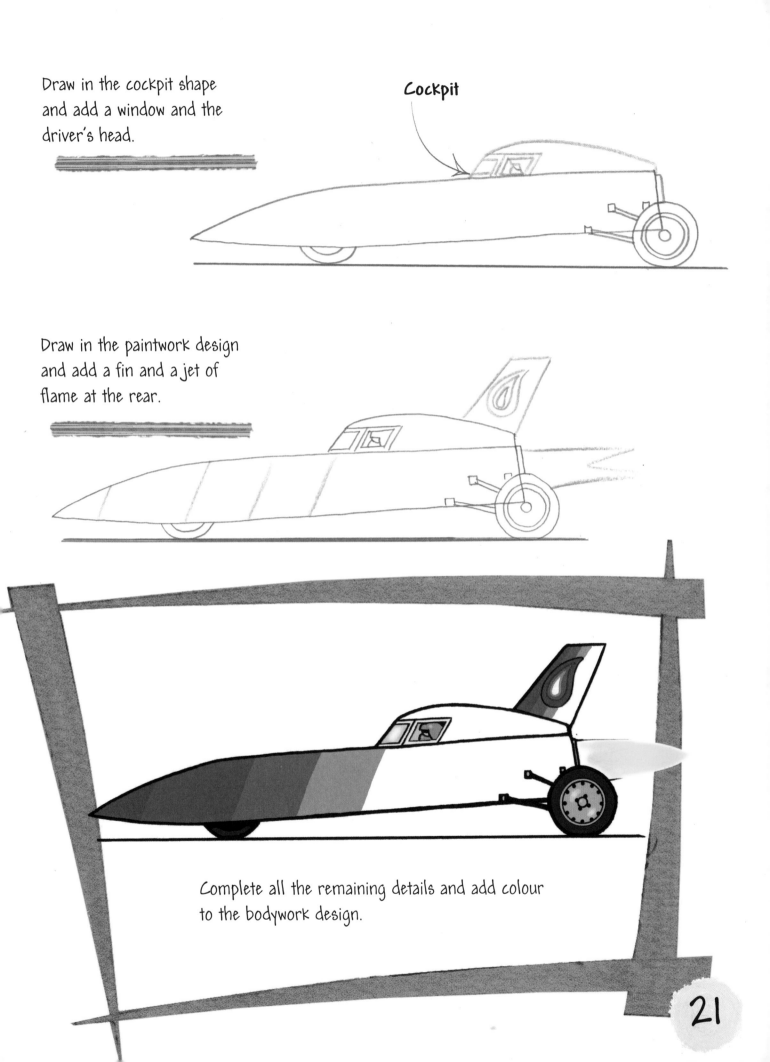

Complete all the remaining details and add colour to the bodywork design.

Space Shuttle

The Space Shuttle could carry astronauts and large payloads into space and then return to Earth to be used again.

Draw a rectangle for the main fuel tank. Add a long rectangle on each side of it for the Solid Rocket Boosters (SRBs)

Fuel Tank

SRB **SRB**

Nose cone

Add a nose cone to each section and add fairings and nozzles to the SRBs.

Fairings

Nozzle

Draw in the main body of the shuttle.

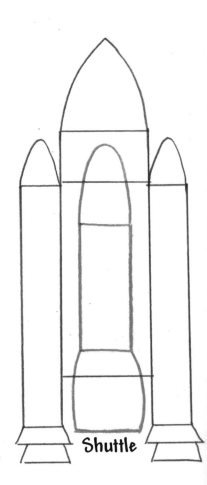

Shuttle

Draw in the shuttle's wings and tail fin.

Add extra details to the SRBs. Draw in the shuttle's windows and engine nozzles. Add three jets of flame.

Add any remaining detail to finish off your shuttle and then colour in the different sections.

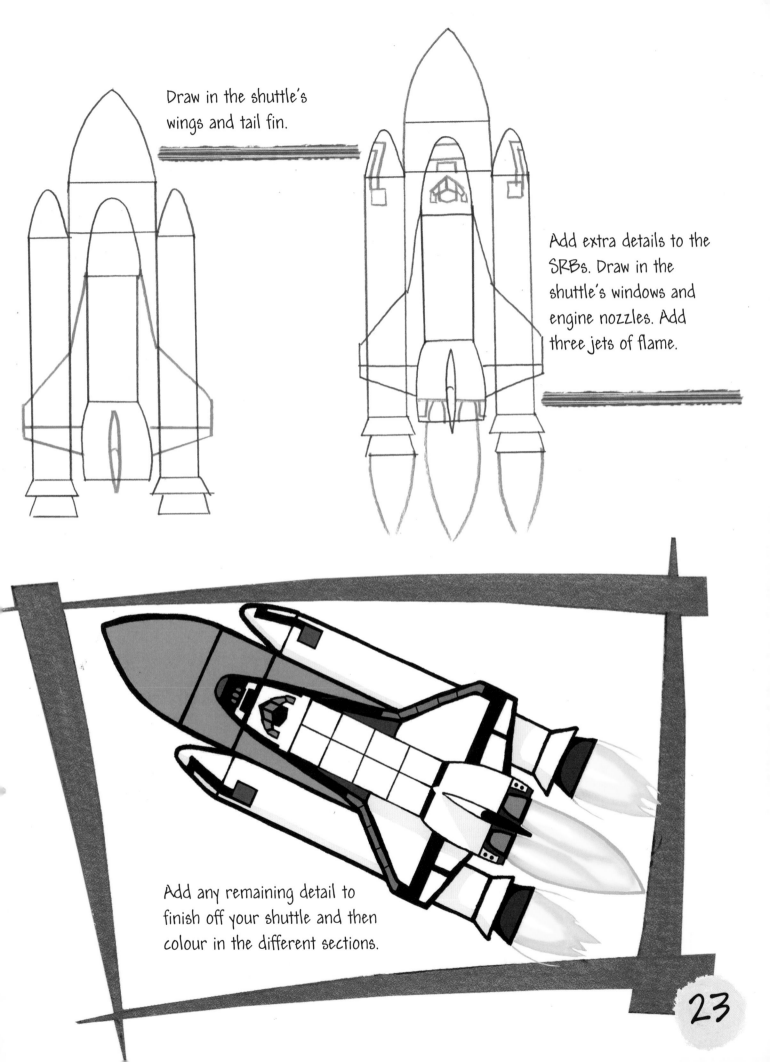

X-15

The X-15 is a high-speed experimental aircraft. It holds the world's speed record for a manned rocket-powered aircraft, reaching a speed of 7,272.626 kph (4,519 mph)!

Draw in the main bullet-shaped fuselage.

Add the cockpit and the tail fin.

Cockpit

Tail fin

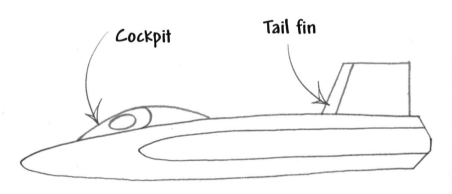

Fuel tank

Draw in the auxiliary fuel tanks and the rear bottom tail fin.

Tail fin

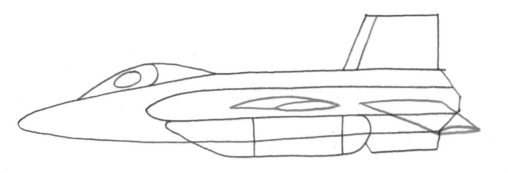

Draw in a wing and rear horizontal stabilisers.

Add all remaining details to the X-15.

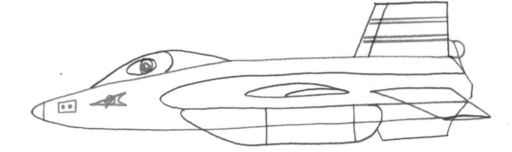

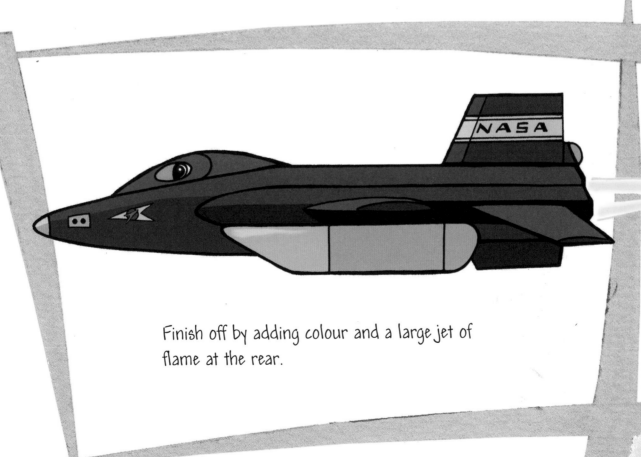

Finish off by adding colour and a large jet of flame at the rear.

Ariane

The Ariane rocket was developed in Europe in the 1970s. It is capable of carrying large payloads, such as satellites, into orbit.

Draw a tall rectangle for the main body of the rocket.

Add a nose cone to the top and a nozzle to the bottom.

Add some detail to the main rocket sections.

Add a rectangle on either side of the rocket body for the SRBs.

SRB

SRB

Add a nose cone and other small details to each SRB. Draw in the SRB fairings and nozzles, then add jets of flame.

Complete any remaining details and add colour.

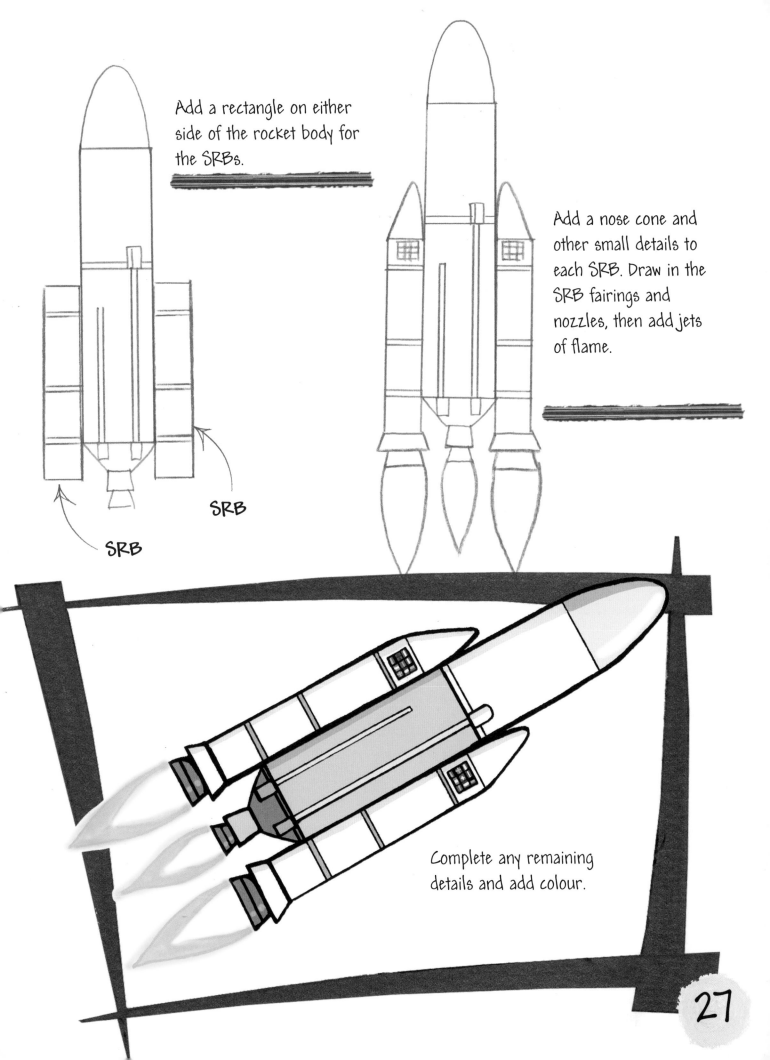

SpaceShipOne

SpaceShipOne completed the first ever manned 'tourist' spaceflight in 2004.

Start by drawing the main body shape with an overlapping wing structure.

Add long extensions to each wing.

Add detail to the wings.

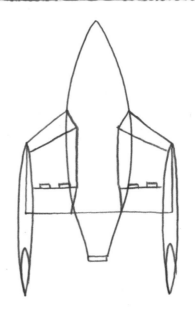

Windows

Draw in the windows.
Add a large jet of flame
at the base.

Fins

Add fins to the
wing structure.

Finish off by adding
colour and perhaps
adding a design.

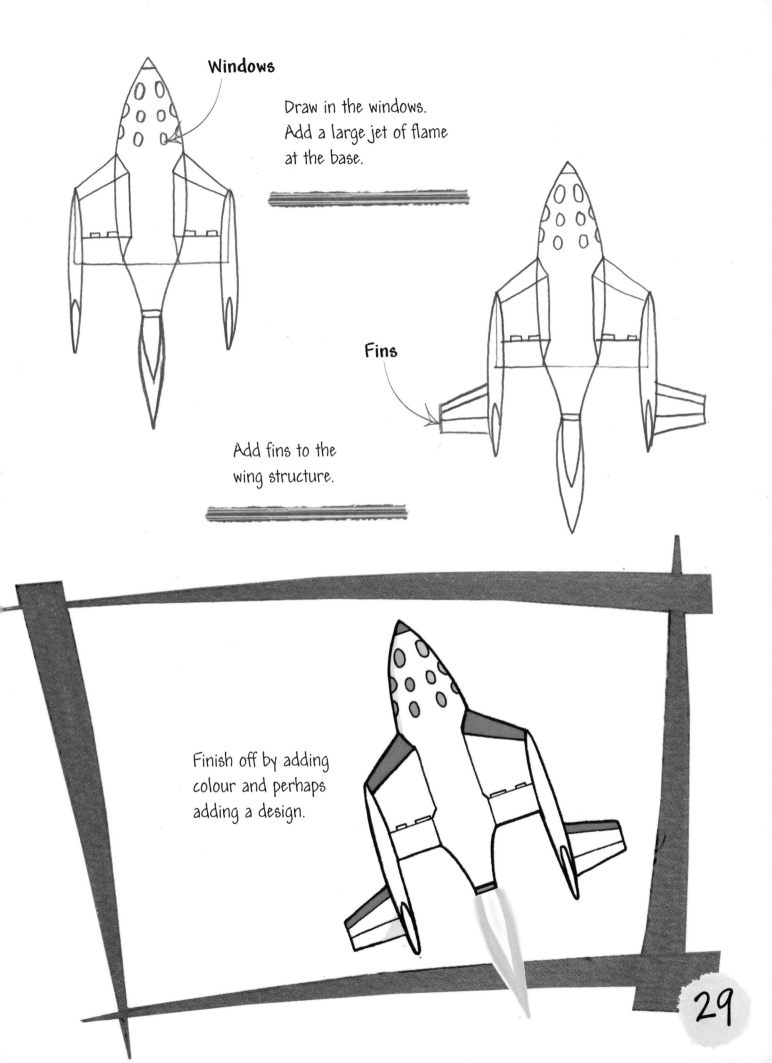

More views

For an extra challenge try drawing rockets from the front or rear! Practising different views will help you improve your drawing.

Back view

Start by drawing a large circle with two smaller circles on either side of it.

Draw in the shape of the space shuttle and add more details to the rocket nozzles.

Add the shuttle's wings and tail fin and join it to the fuel tank.

Add the small details to finish off. A pencil has been used to draw this example. Try other materials to create a different look.

Space Shuttle

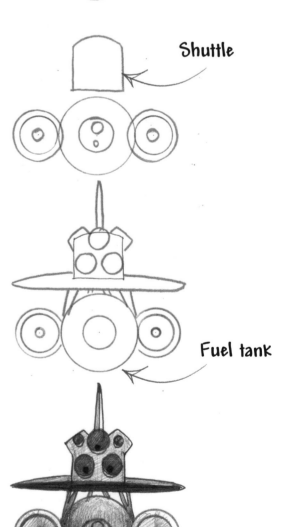

Shuttle

Fuel tank

Front view

Start by drawing
two circles, one
inside the other.

Saturn V

Add one more circle.

Draw in the curved
fairings, the fins and the
square escape tower.
Start to add the design.

Fins

Fairings

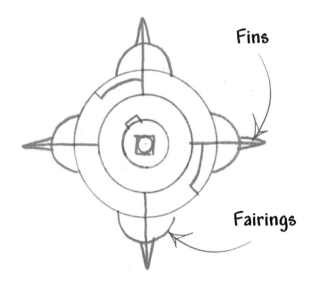

Finish off this view of the
rocket by adding any extra
details. Now colour it in if
you want!

Glossary

auxiliary fuel tank A fuel tank that is detached from a rocket during a spaceflight.

command module The detachable portion of a spacecraft in which the astronauts live.

construction lines Guidelines used in the early stages of a drawing. They are usually erased later.

escape tower A tower connecting to an escape rocket, used in emergencies.

fairing A component that temporarily protects the payload of a spacecraft.

fuselage The main body of a spacecraft or aircraft.

payload The cargo of an aircraft or spacecraft, which could include extra fuel or scientific equipment.

rocket nozzle A component that increases the power of fuel in the rocket.

satellite A machine which orbits Earth.

SRB (solid rocket booster) A component that provides a boost to the rocket to help it launch.

stabiliser A horizontal or vertical wing which helps to balance the spacecraft or vehicle out.

sub-orbital flight A spaceflight which reaches space but doesn't go far enough to enter the planet's orbit.

supersonic Faster than the speed of sound.

Index